GREAT
AIRCRAFT
COLORING BOOK

CHARTWELL
BOOKS

This edition published in 2014 by
CHARTWELL BOOKS
an imprint of Book Sales
a division of Quarto Publishing Group USA Inc.
276 Fifth Avenue Suite 206
New York, New York 10001
USA

Copyright © 2014 Amber Books Ltd

ISBN: 978-0-7858-3138-9

Editorial and design by
Amber Books Ltd
74–77 White Lion Street
London
N1 9PF
United Kingdom
www.amberbooks.co.uk

Project Editor: Michael Spilling
Design: Mark Batley
Picture research: Terry Forshaw
Text: Kieron Connolly

All artworks courtesy Art-Tech/Aerospace and Patrick Mulrey

Printed in China

Contents

Spad XIII biplane

Described by American air ace Captain Eddie Rickenbacker as "the best ship I ever flew," the French SPAD XIII was one of the fastest aircraft flown during World War I. In all, more than 8,472 were built. The cockrel on the fuselage is the emblem of the SPA.48 unit, whose motto was "Sing and Fight" (*Chante et Combat*).

Specifications

Maximum speed: 224 mph (139 km/h)
Range: 171 miles (276 km)
Crew: 1
Armament: Two 0.30 in (7.62 mm) forward-firing Vickers machine guns

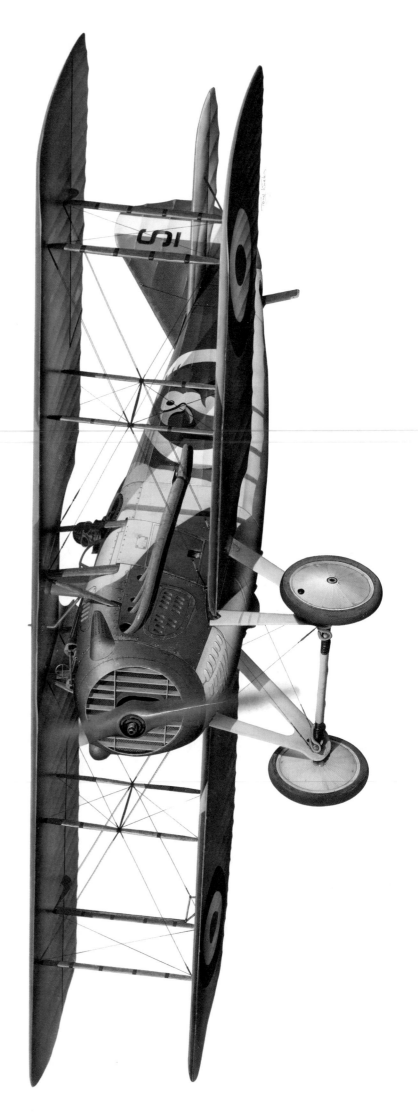

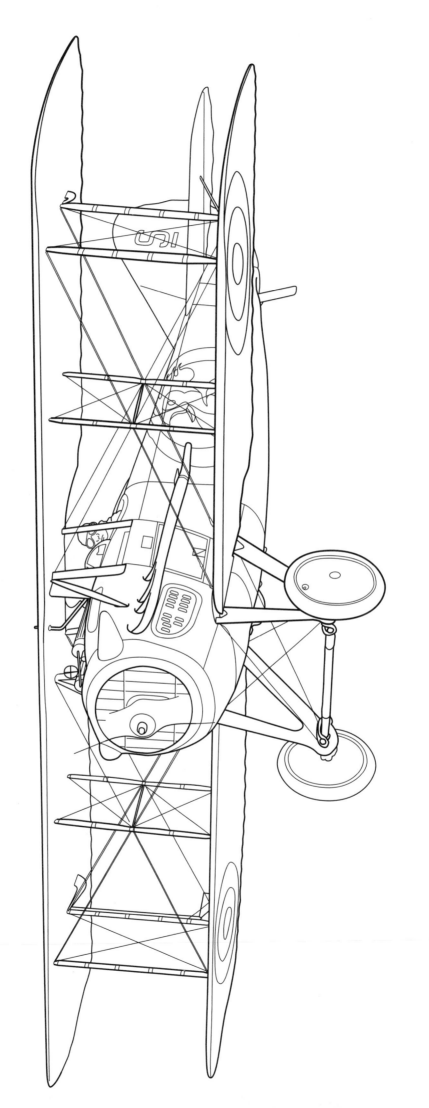

Fokker Dr. I triplane

One of the best known aircraft of World War I, this Fokker Dr. I triplane was flown by German Manfred von Richthofen—the "Red Baron." Richthofen led the fighter unit JG 1, which was famous for its air combat techniques and for each plane having a unique color scheme. That way, unit members could easily identify each other.

Specifications

Maximum speed: 115 mph (185 km/h)
Range: 185 miles (300 km)
Crew: 1
Armament: Two 0.31 in (7.92 mm) machine guns

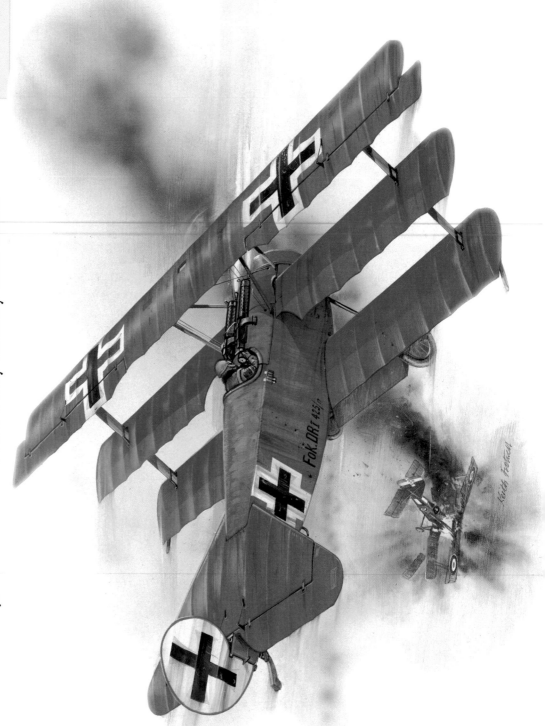

Bristol Bulldog II

The British Royal Air Force (RAF) first introduced radios and oxygen supply on a fighter with the Bulldog II in 1928. Some Bulldogs were still being used by the RAF at the beginning of World War II in 1939. Many were exported, with both Finland and Sweden operating their Bulldogs on skis.

Specifications

Maximum speed: 174 mph (280 km/h)
Range: 350 miles (563 km)
Crew: 1
Armament: Two 0.303 in (7.7 mm) Vickers machine guns

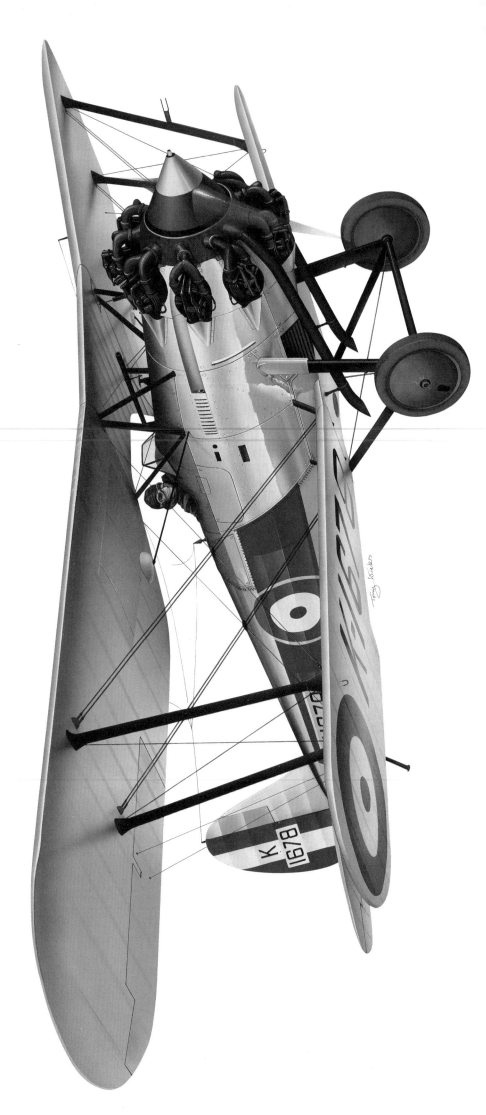

Polikarpov I-16

The Polikarpov I-16 was the first production plane with a retractable undercarriage. Built by the Soviet Union, it first flew in 1933 and served up until 1940. This particular aircraft flew for Republican forces in the Spanish Civil War (1936–39). A "Popeye" graphic can be seen on its tail. In total, 6,555 I-16s were built.

Specifications

Maximum speed: 304 mph (489 km/h)
Range: 435 miles (700 km)
Crew: 1
Armament: Four 0.30 in (7.62 mm) machine guns; external bomb and rocket load of 1102 lb (500 kg)

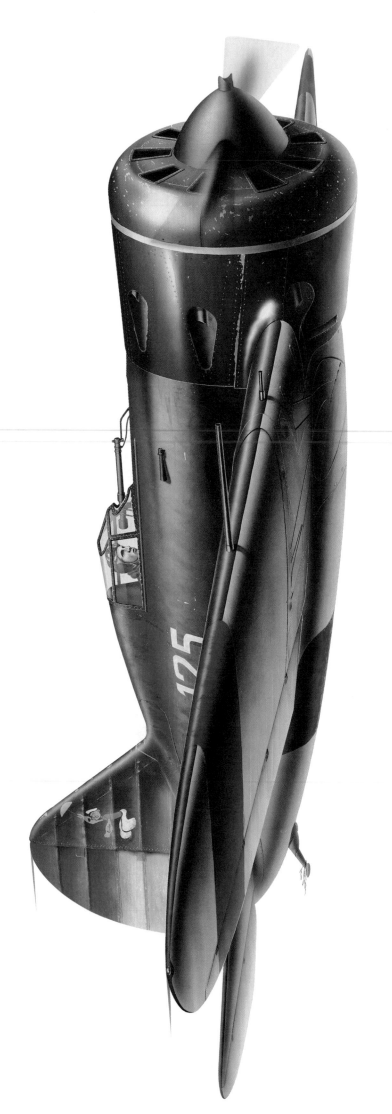

Junkers Ju 87 Stuka

Stuka is an abbreviation of the German word for dive-bomber. Known for the screaming sound that it made while diving at ground targets during World War II, the Stuka was fitted with a device to pull the aircraft out of a steep dive, even if the pilot had blacked out and lost control.

Specifications

Maximum speed: 237 mph (380 km/h)
Range: 372 miles (600 km)
Crew: 2
Armament: Three 0.31 in (7.92 mm) machine guns; external bomb load of up to 2,205 lb (1,000 kg)

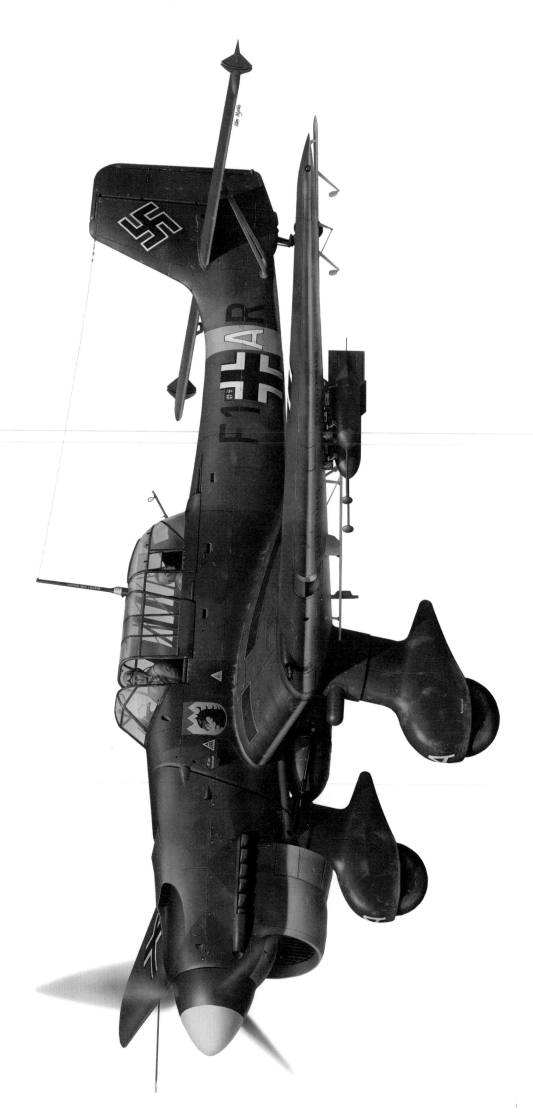

Messerschmitt Bf 109E

Germany's leading fighter in World War II, more than 4,000 Bf 109Es were built, and more than 30,000 Bf 109s in total. While its rear wheel can be seen here, the Bf 109 was one of the first aircraft to draw its main wheels into the fuselage during flight, just as most aircraft do today.

Specifications

Maximum speed: 84 mph (560 km/h)
Range: 410 miles (660 km)
Crew: 1
Armament: Two 20mm (0.79 in) fixed forward-firing cannon, two 7.92mm (0.31in) machine guns

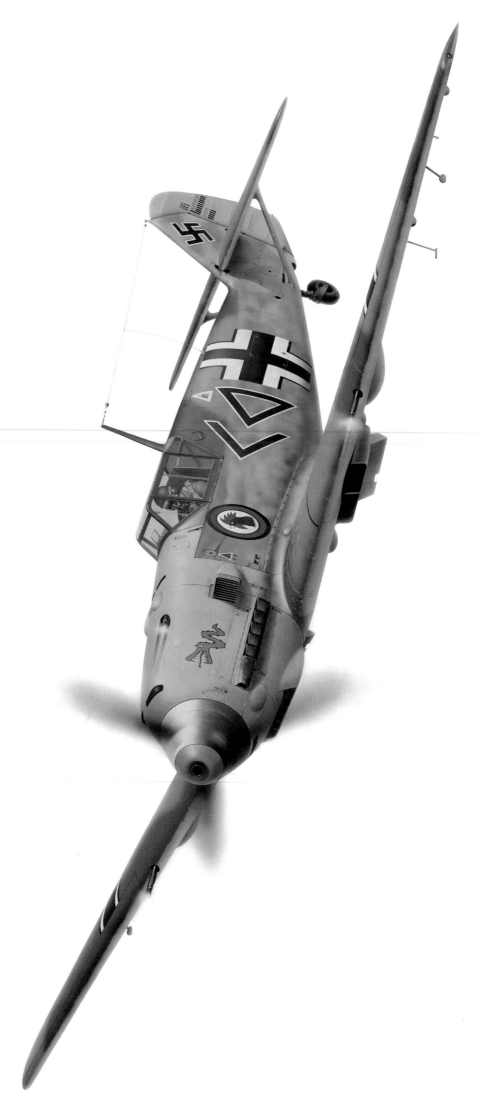

Consolidated PBY Catalina flying boat

One of the classic designs, the Catalina served in reconnaissance, anti-shipping, marine patrol and convoy roles during World War II. This particular aircraft was used by the RAF and was fitted with radar to spot surfaced U-boats. The antennae can be seen beneath the wings, with a surveillance radar above the flight deck.

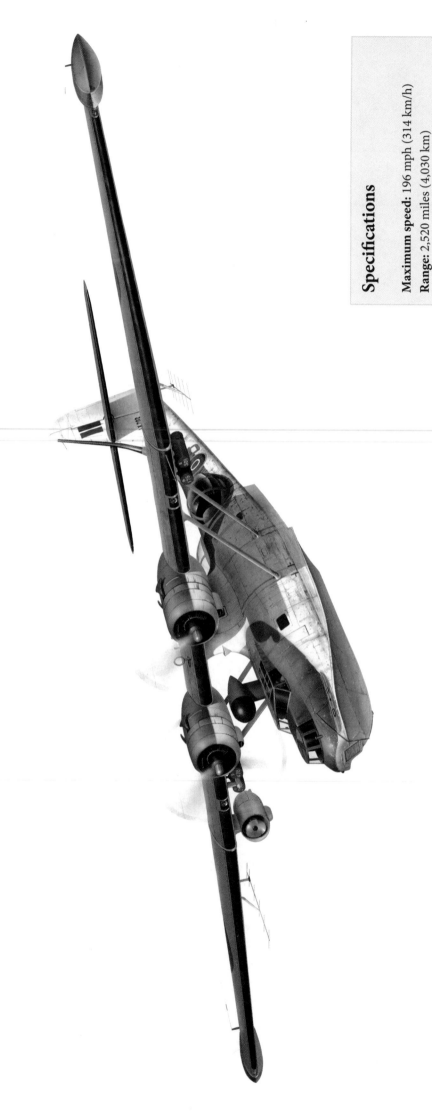

Specifications

Maximum speed: 196 mph (314 km/h)
Range: 2,520 miles (4,030 km)
Crew: 10
Armament: One machine gun in the bow turret, two 0.303 in (7.7 mm) machine guns in the waist blisters

Handley Page Halifax

The Halifax was a British four-engined bomber flown during World War II. It was also used as a passenger transport aircraft and in reconnaissance missions. The bomb aimer's position was in the nose of the plane. Above him sat the forward gunner. There was also a gun turret on the top of the aircraft and one in the tail.

Specifications

Maximum speed: 285 mph (460 km/h)
Range: 1,030 miles (1,657 km)
Crew: 7
Armament: Two 0.50 in (12.7 mm) machine guns in tail turret, four 0.303 in (7.7 mm) machine guns in dorsal turret, and one in nose; bomb load of up to 13,000 lb (5,895 kg)

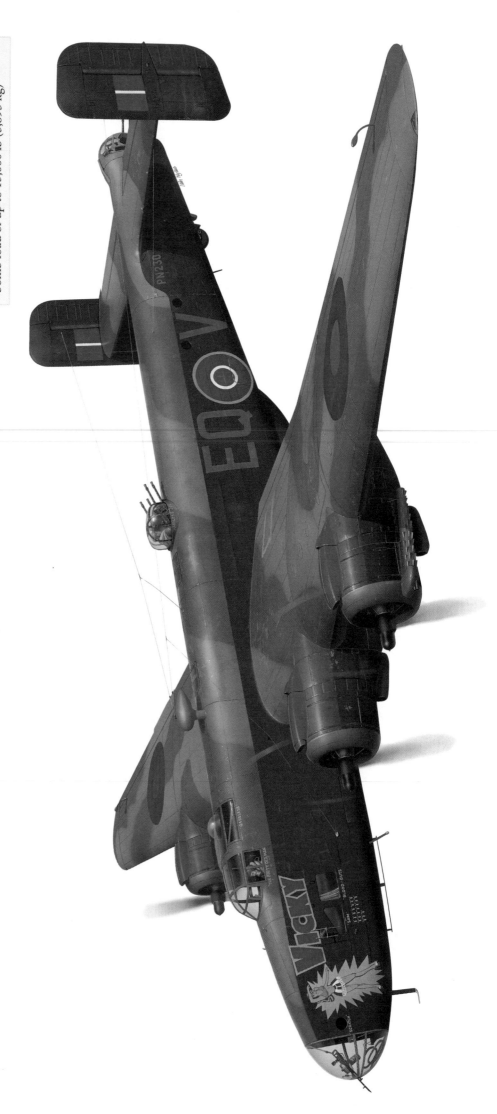

Mitsubishi A6M2 "Zero"

Launching from Japanese aircraft carriers, the A6M2 was one of the finest aircraft of its era. In firepower, agility, and range, it was superior to the American fighters it first encountered during World War II. Of 125 A6Ms which took part in the raid on Pearl Harbor in 1941, only nine failed to return.

Specifications

Maximum speed: 332 mph (534 km/h)
Range: 1,929 miles (3,104 km)
Crew: 1
Armament: Two 0.79 in (20 mm) cannon, plus two fixed 0.303 in (7.7 mm) machine guns; external bomb load of 265 lb (120 kg)

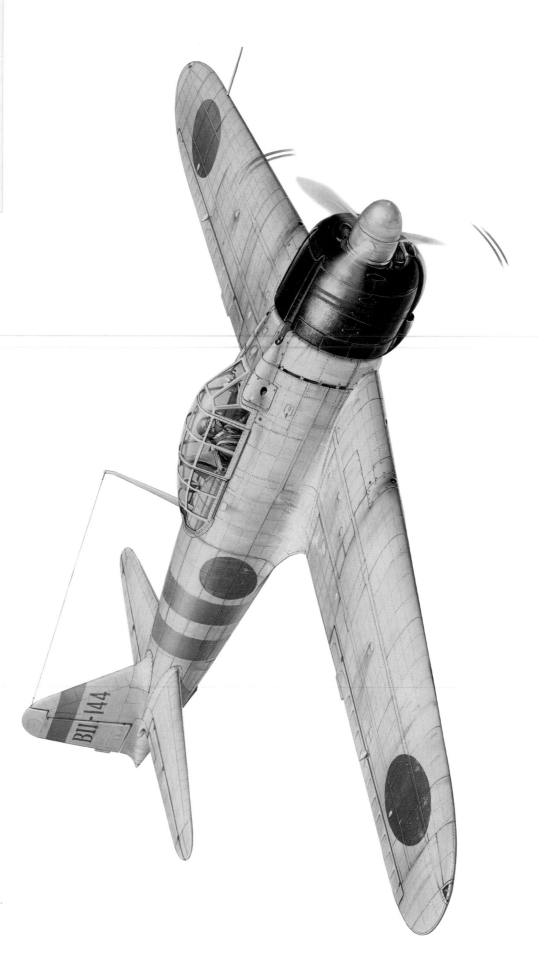

Grumman F4F-3 Wildcat

Mainly used as a fighter launched from American aircraft carriers during World War II, the Wildcat had wings that folded to allow it to be stored below deck more easily. While its main adversary, the Japanese Mitsubishi A6M "Zero," held the advantage in performance, the Wildcat was noted for the excellent pilots who flew it.

Specifications

Maximum speed: 331 mph (531 km/h)
Range: 845 miles (1,360 km)
Crew: 1
Armament: Four 0.50 in (12.7 mm) machine guns; two 100 lb (45 kg) bombs and/or two 58 gallon (220 liter) drop tanks

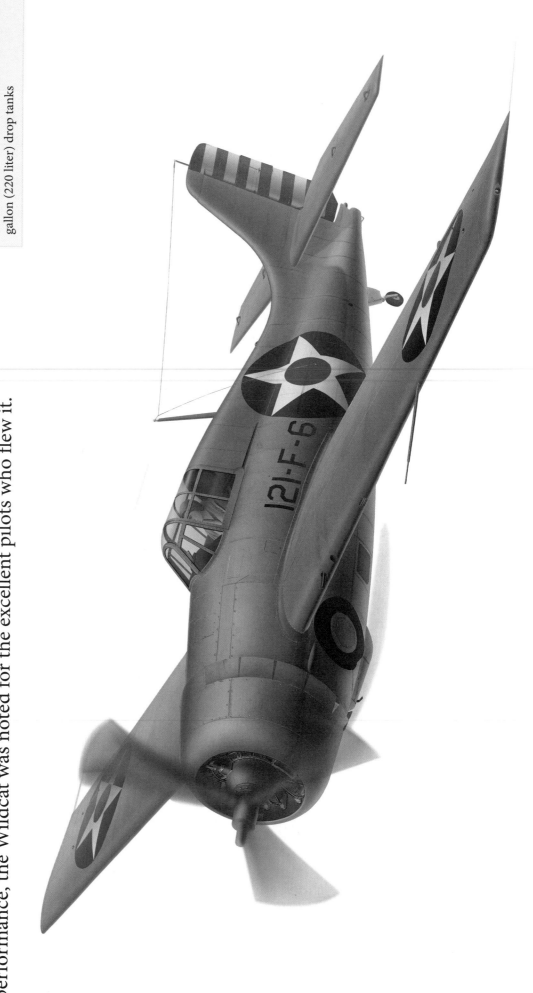

Boeing B-17G Flying Fortress

One of the most important bombers of World War II, the B-17 fought from the Pacific to North Africa to Europe. A B-17 shot down by Japanese aircraft on their way to Pearl Harbor was the first US combat loss in World War II. The observation dome in front of the flight deck allowed the navigator to take readings using a sextant.

Specifications

Maximum speed: 287 mph (462 km/h)
Range: 2,000 miles (3,220 km)
Crew: 10
Armament: Thirteen 0.50 cal (12.7 mm) machine guns in eight positions: chin turret, nose cheeks, waist guns, dorsal turret, belly turret, and tail positions; 17,640 lb (8,000 kg) maximum bombload

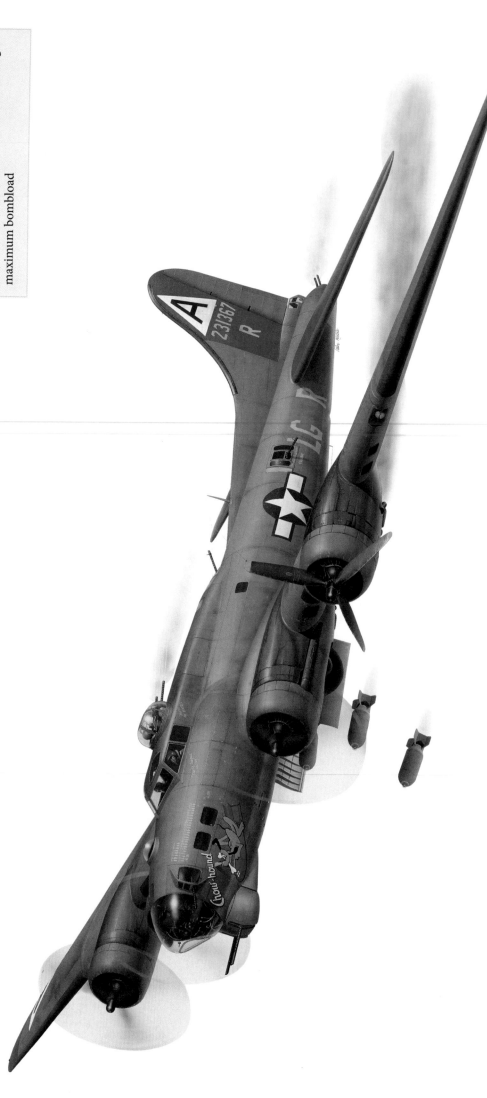

Supermarine Spitfire Mk XIV

The most famous British aircraft of all time, the Spitfire was among the fastest and most maneuverable fighters of World War II. Best known for defeating German planes in the skies over England in the Battle of Britain, the Spitfire also served across Europe and in North Africa.

Specifications

Maximum speed: 448 mph (721 km/h)
Range: 850 miles (1,368 km)
Crew: 1
Armament: Two 0.79 in (20 mm) forward-firing cannon and four 0.303 in (7.7 mm) machine guns; external bomb load of 500 lb (227 kg)

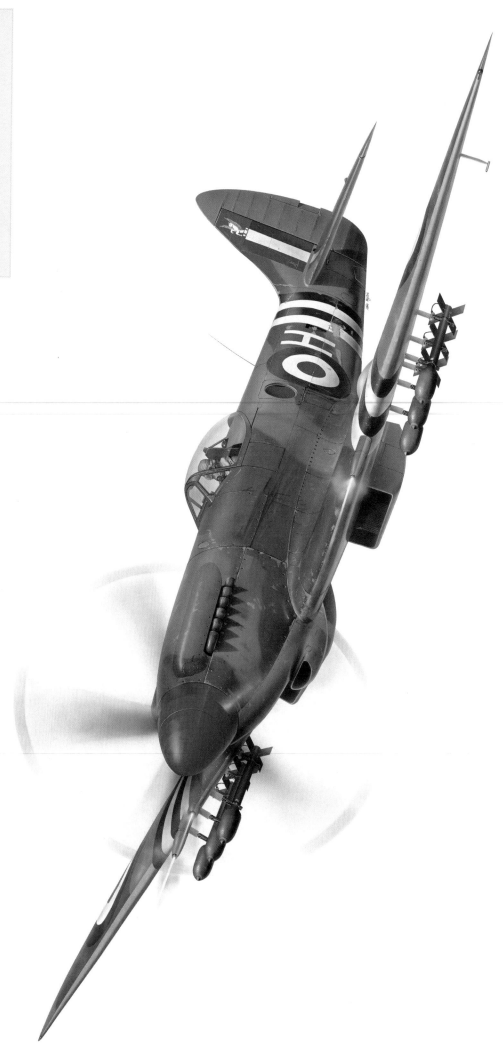

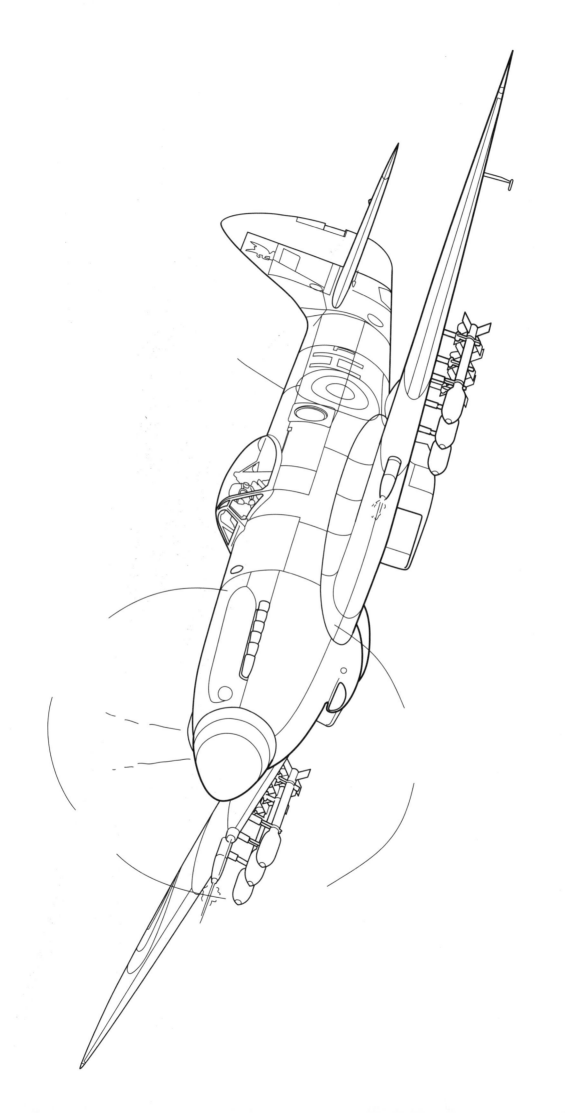

De Havilland DH.100 Vampire

The Vampire was Britain's second jet fighter after the Gloster Meteor. Its fuselage pod was made of plywood and balsa wood construction, while the wings and tailplane were metal. A single-seat day fighter, it was first flown in 1945 and was used by the RAF until 1953. It was the first jet aircraft to cross the Atlantic Ocean.

Specifications

Maximum speed: 530 mph (853 km/h)
Range: 1145 miles (1,842 km)
Crew: 1
Armament: Four 0.79 in (20 mm) cannon, eight 60 lb (27 kg) rockets, and two 500 lb (227 kg) bombs, or two 1000 lb (454 kg) bombs

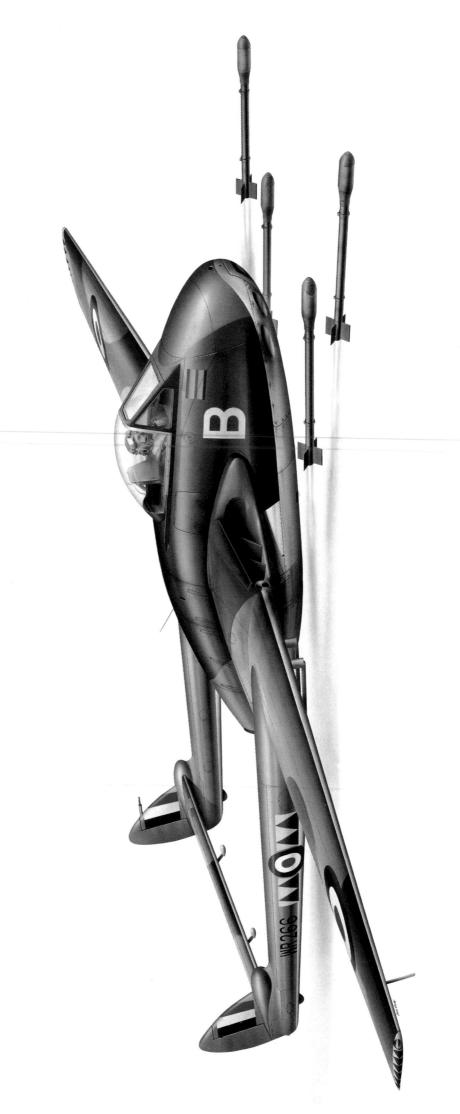

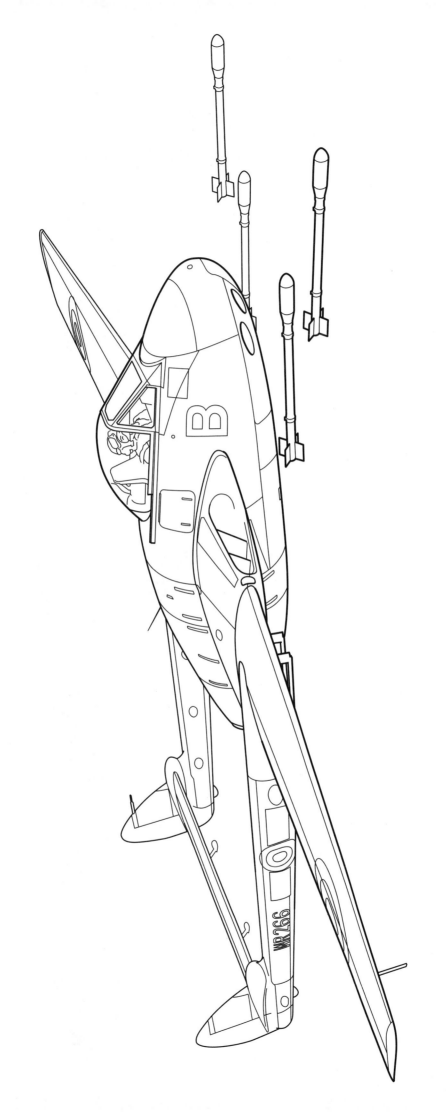

Boeing B-52G Stratofortress

The first B-52s were completed in 1958 and would serve the United States Air Force in bombing raids over Vietnam in the late 1960s and early 1970s. Although the B-52 had tail guns, the tail-gunner's position was moved from the rear fuselage to a seat in the main forward cabin, where he operated the guns using a video monitor or radar.

Specifications

Maximum speed: 636 mph (1,024 km/h)
Range: 7,976 miles (12,836 km)
Crew: 5
Armament: Four 0.50 in (12.7 mm) machine guns in tail turret; maximum ordnance of 50,000 lb (22,680 kg)

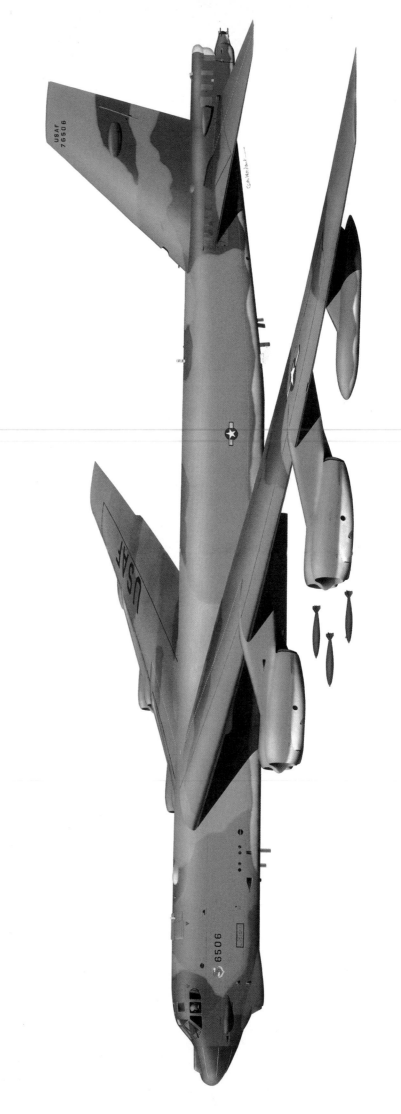

Mikoyan-Gurevich MiG-17

Entering service in 1952, the Soviet-made MiG-17 fighter saw action in the Congo, the Nigerian civil war, in the Middle East and over North Vietnam, where it proved a nimble opponent for more modern types, such as the F-4 Phantom. The example shown here was one of 48 delivered to Mozambique in the late 1970s.

Specifications

Maximum speed: 711 mph (1,145 km/h)
Range: 913 miles (1,470 km)
Crew: 1
Armament: One 1.46 in (37 mm) cannon plus two 0.91 in (23 mm) cannon; up to 1,102 lb (500 kg) of underwing stores

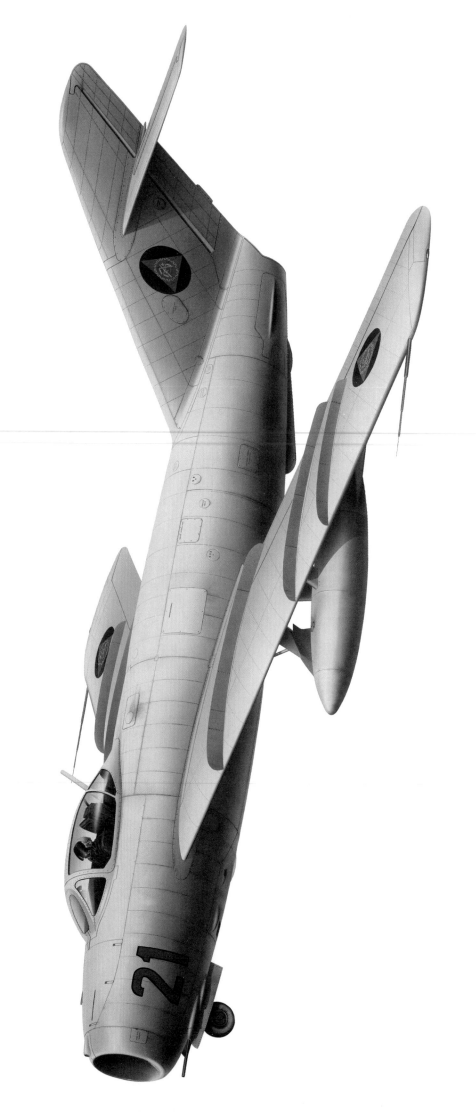

Lockheed C-130 Hercules

Since first flying in 1954, the Hercules has proved to be a highly versatile aircraft, mainly used for transport, but also as a gunship and for weather reconnaissance. It is able to take off from unprepared runways and can be used to refuel other aircraft mid-flight. The pictured aircraft served with the British Royal Air Force.

Specifications

Maximum speed: 340 mph (547 km/h)
Range: 3,820 miles (6,145 km)
Crew: 4
Capacity: 92 passengers, or 64 airborne troops, or 74 litter patients and medical teams, or two M113 armored personnel carriers

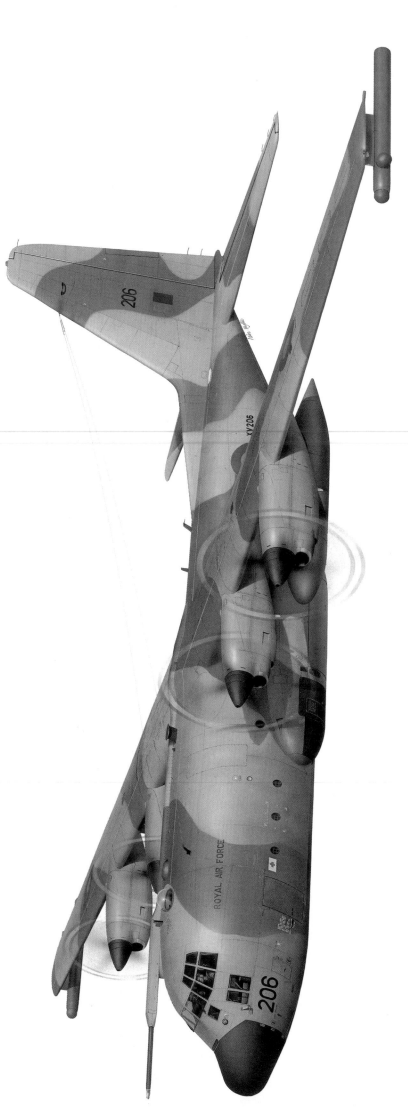

Mikoyan-Gurevich MiG-21

Following the Korean War (1950–53), the Soviet air force realized it needed a light, single-seat fighter and interceptor that was agile and could reach supersonic speeds. Entering service in 1960, the MiG-21 became the most widely used jet fighter in the world, being license-built in Czechoslovakia, China and, as pictured below, India.

Specifications

Maximum speed: 1,384 mph (2,230 km/h)
Range: 1,118 miles (1,800 km)
Crew: 1
Armament: One 0.9 in (23 mm) cannon; two air-to-air missiles on underwing pylons

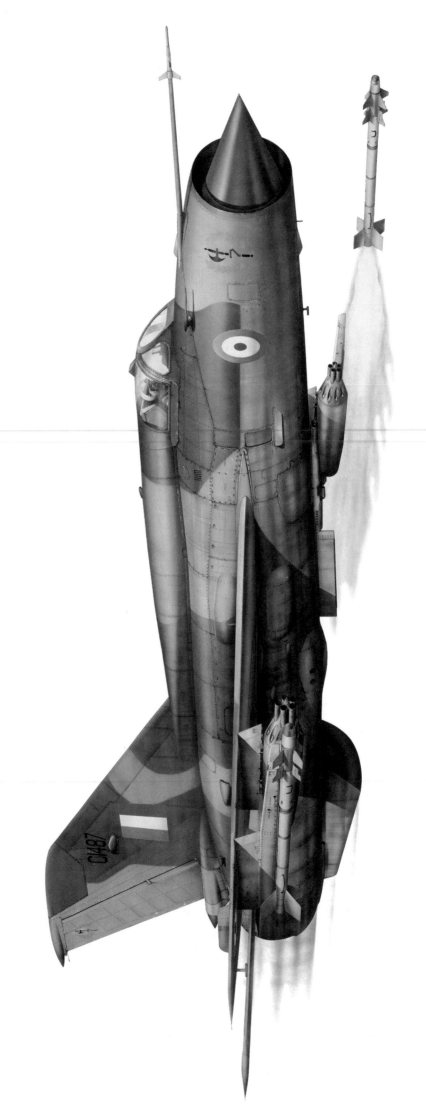

McDonnell Douglas F-4 Phantom II

Entering service in 1960, the Phantom II was a long range, supersonic jet. Used extensively during the Vietnam War, it was later adapted to carry the electronics and weaponry needed to hit enemy surface-to-air missile radars. The F-4G Wild Weasel pictured housed radar antennae in its torpedo-shaped nose.

Specifications

Maximum speed: 1,485 mph (2,390 km/h)
Range: 1,750 miles (2,817 km)
Crew: 2
Armament: 12,980 lb (5,888 kg) of ordnance and stores on underwing pylons, including anti-radiation missiles

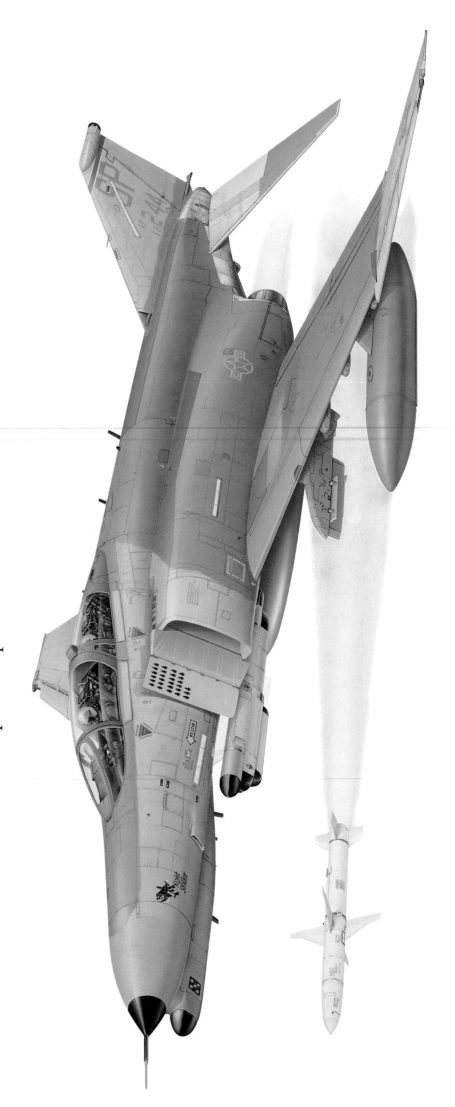

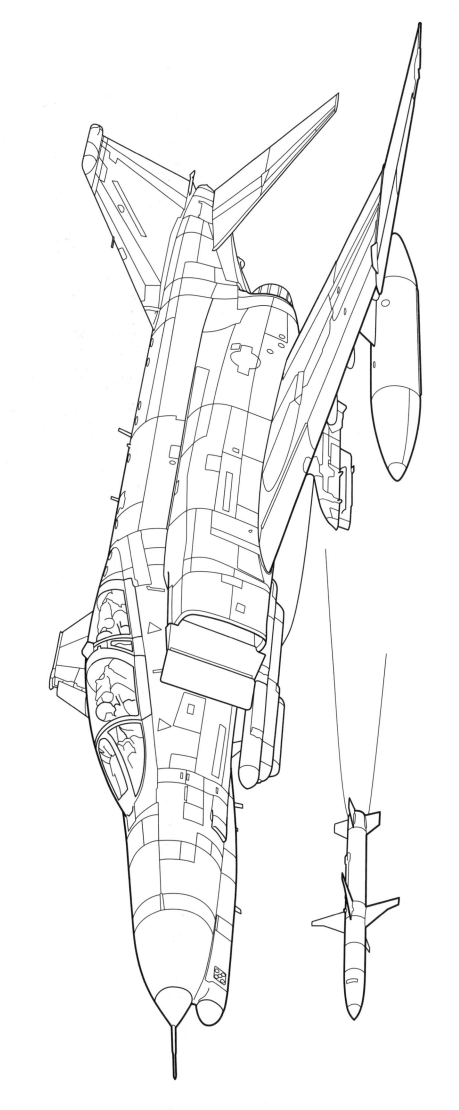

Tupolev Tu-22M

Was it a bomber? An intercontinental attack aircraft? Or something else? First flying in 1971, the Tu-22M initially puzzled NATO forces during the Cold War as to its role. In fact, it was an anti-shipping attack aircraft using air-to-surface missiles. It served with the Soviet Northern Fleet in the North Atlantic and also on the Black Sea.

Specifications

Maximum speed: 1,321 mph (2,125 km/h)
Range: 2,485 miles (4,000 km)
Crew: 4
Armament: One 0.9 in (23 mm) twin-barrel cannon in tail; up to 26,455 lb (12,000 kg) of stores in weapons bay or one S-4 missile

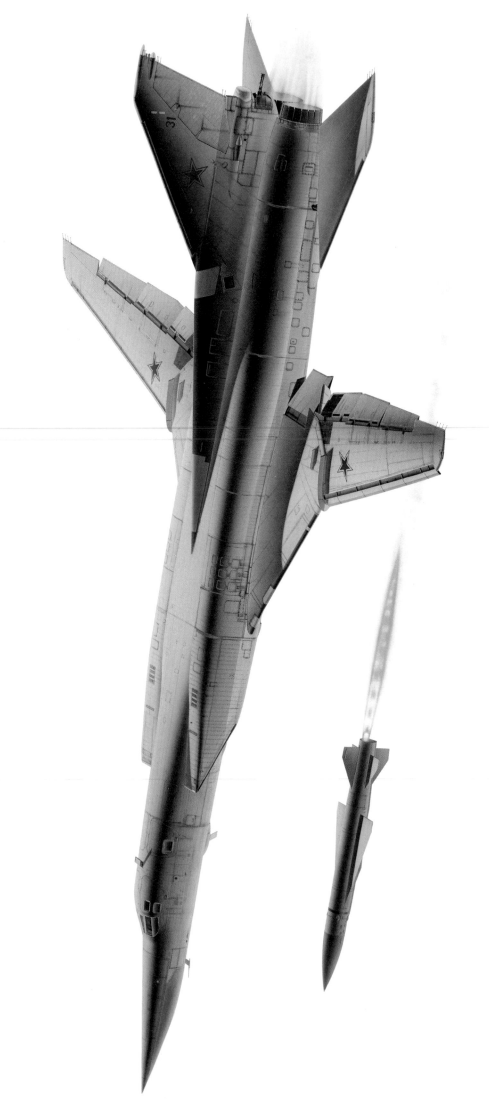

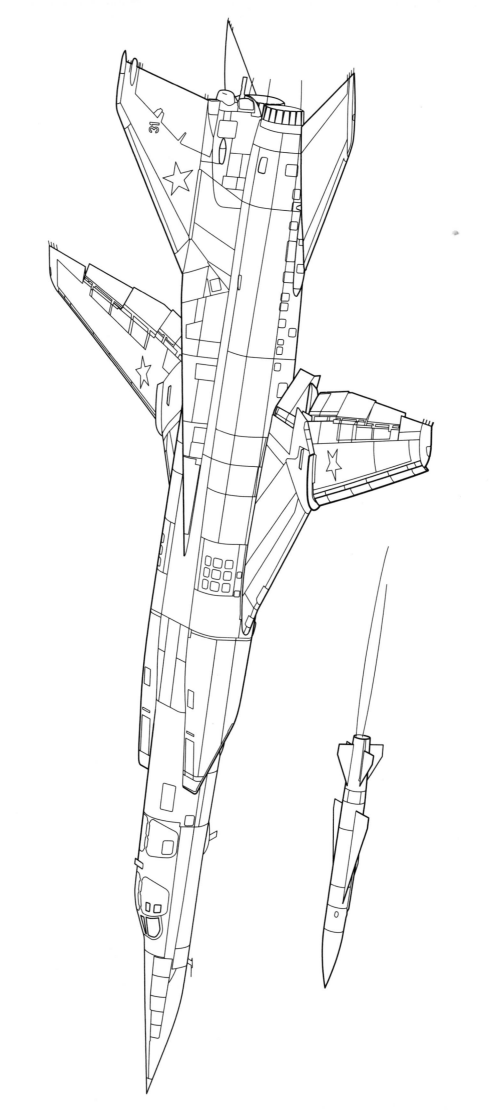

Fairchild A-10 Thunderbolt II

Designed to destroy Soviet armor in Europe with its massive 1.18 in (30 mm) cannon, the Thunderbolt II was introduced in 1977. Its unusual airframe was shaped for survivability—the cockpit and aircraft systems are protected from ground fire by 1200 lb (540 kg) of titanium armor. It served in both Gulf wars (1991, 2003).

Specifications

Maximum speed: 439 mph (706 km/h)
Range: 2,454 miles (3,947 km)
Crew: 1
Armament: One 1.18 in (30 mm) cannon; maximum ordnance load of 16,000 lb (7,758 kg) including bombs, rockets, and missiles

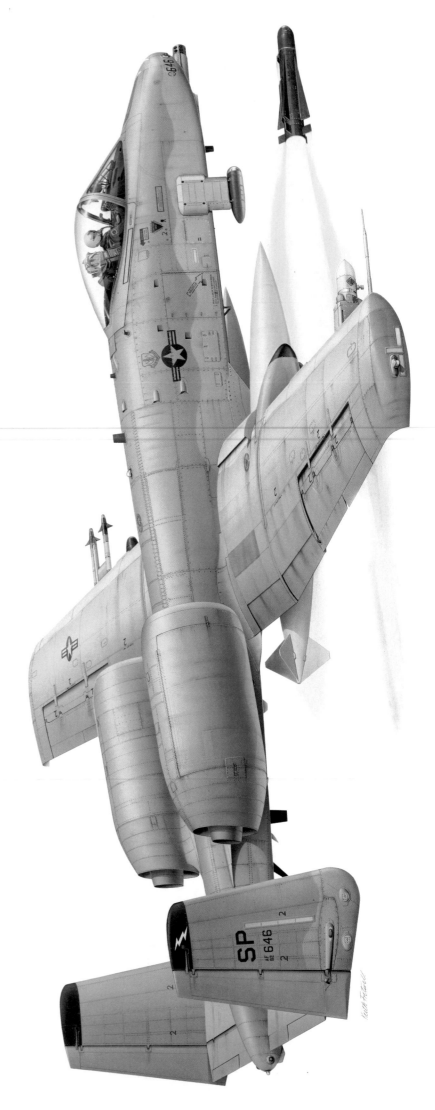

Mikoyan MiG-29 "Fulcrum"

Launched in 1977, the MiG-29 is one of the world's most maneuverable fighters.

In the right hands it can win a dogfight against any warplane in service today.

Unlike Western fighters, the MiG-29 can perform a tailslide, where the aircraft safely falls backward at the top of a climb.

Specifications

Maximum speed: 1,519 mph (2,445 km/h)
Range: 466 miles (750 km)
Crew: 1
Armament: One 1.18 in (30 mm) cannon; maximum 6,614 lb (3,000 kg) of ordnance stored on underwing pylons, including air-to-air and air-to-surface missiles

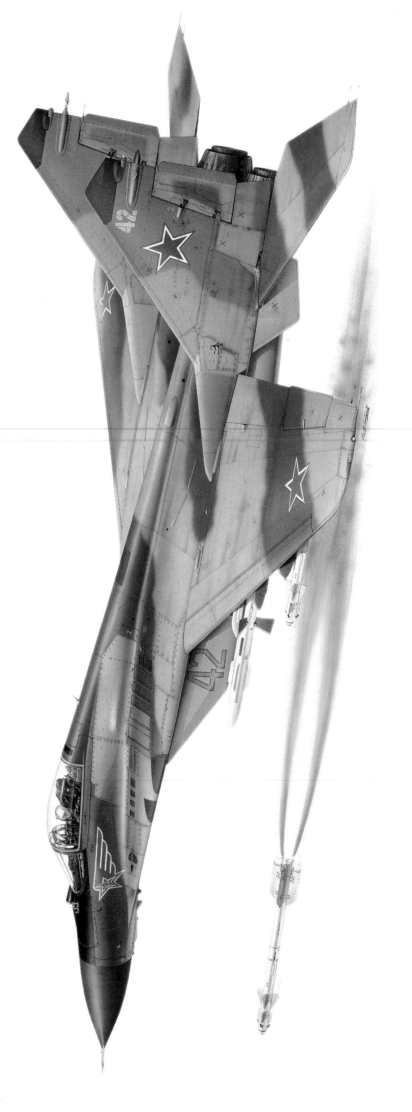

SAAB Viggen

The Viggen is named after the thunderbolt of the Norse god Thor. A ground-attack fighter, the first Viggen were delivered in 1971. It was the first aircraft to feature forward wings just behind the cockpit. These provide extra lift and allow the aircraft to take off from unprepared surfaces, including roadways.

Specifications

Maximum speed: 1,321 mph (2,126 km/h)
Range: 1,243 miles (2,000 km)
Crew: 1
Armament: Carries up to 13,000 lb (5,897 kg) of bombs, rockets, and air-to-surface missiles

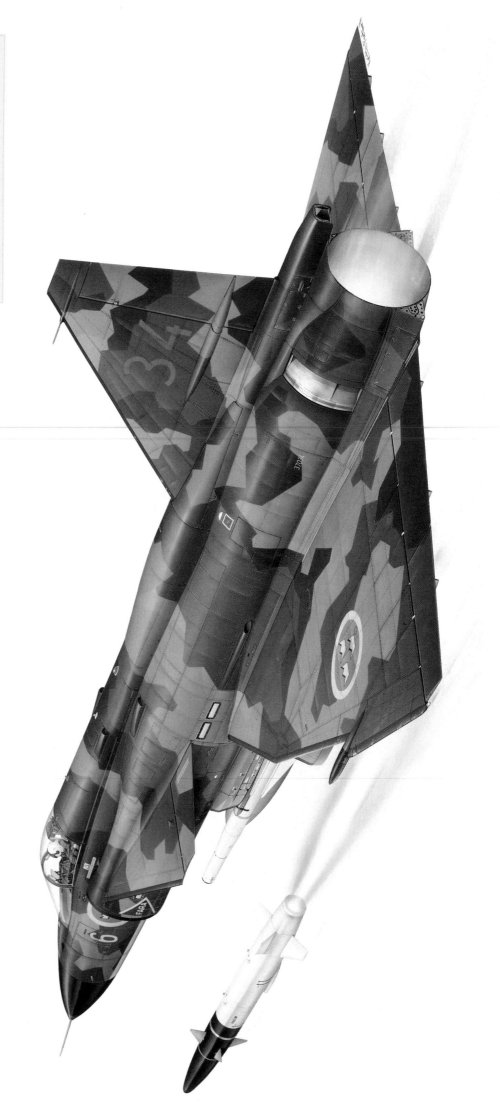

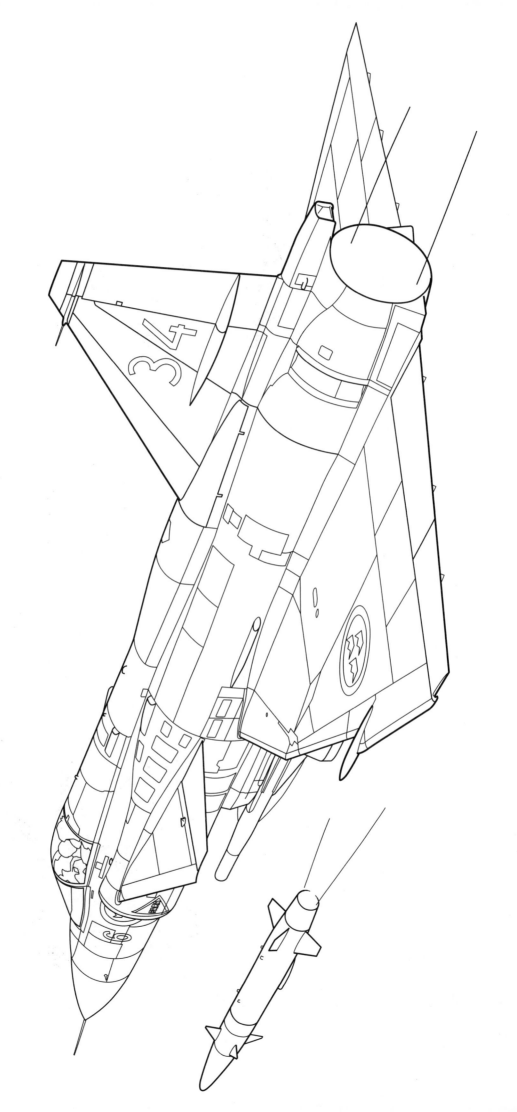

Grumman F-14 Tomcat

With its speed and long-range weapons, the Tomcat was the main interceptor of the US Navy, serving from 1974 until 2006. Its Sidewinder missiles could home in on heat from enemy aircraft jet pipes, while its radar could detect fighter-sized targets at very long range. The aircraft's range could be extended by inflight refuelling.

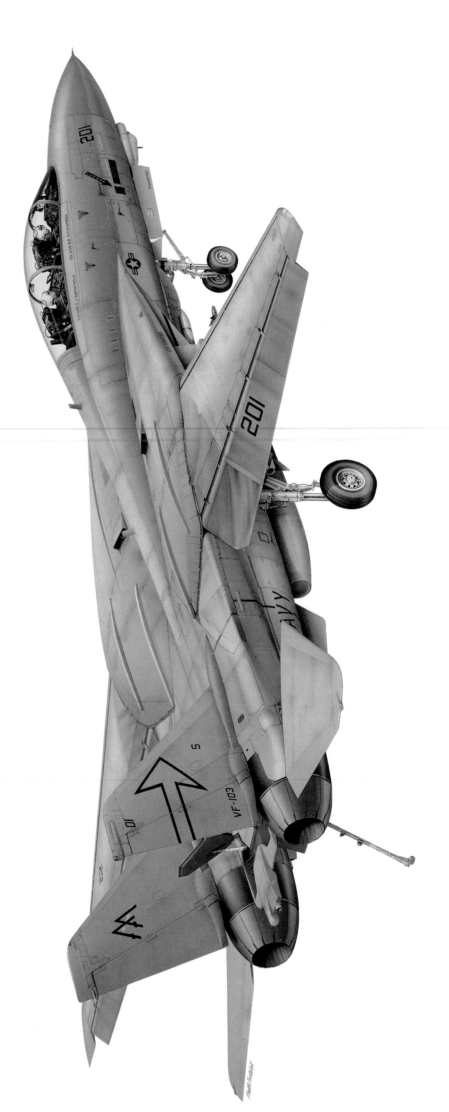

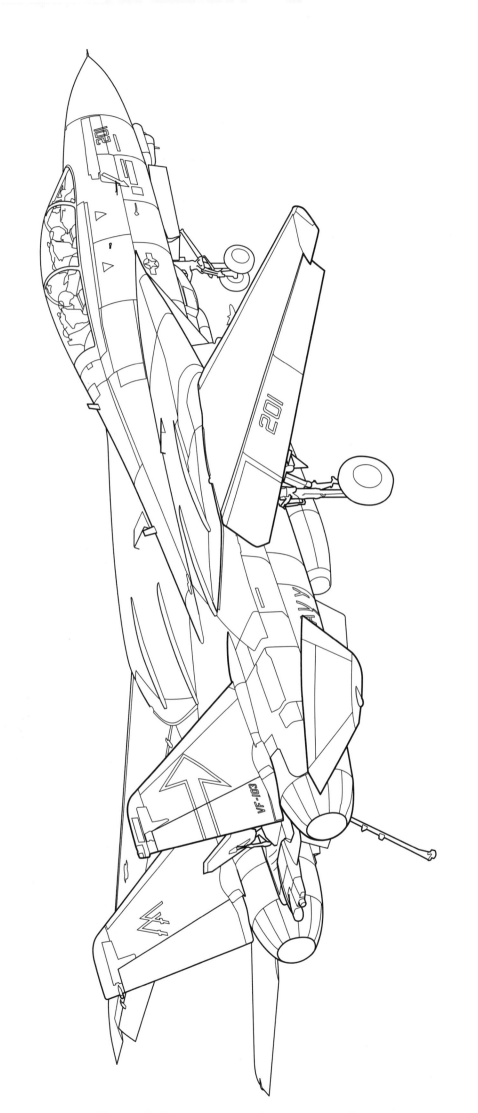

Boeing 747 Jumbo Jet

The Boeing 747 revolutionized air travel by carrying more people further, and at lower cost, than any aircraft before it. Called the "Jumbo Jet" because of its wide-body capacity, it became the backbone of air transport. First flying in 1969, the latest passenger 747s can carry more than 600 passengers. Its undercarriage has 16 wheels to spread the load.

Specifications

Maximum speed: 608 mph (980 km/h)
Range: 8,307 miles (13,398 km)
Crew: 2
Passengers: 416 (standard configuration); 660 (maximum capacity)

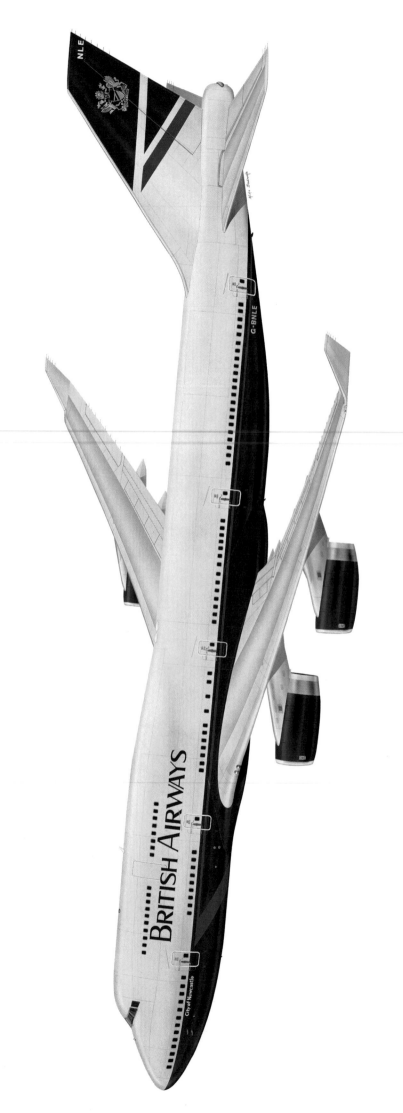

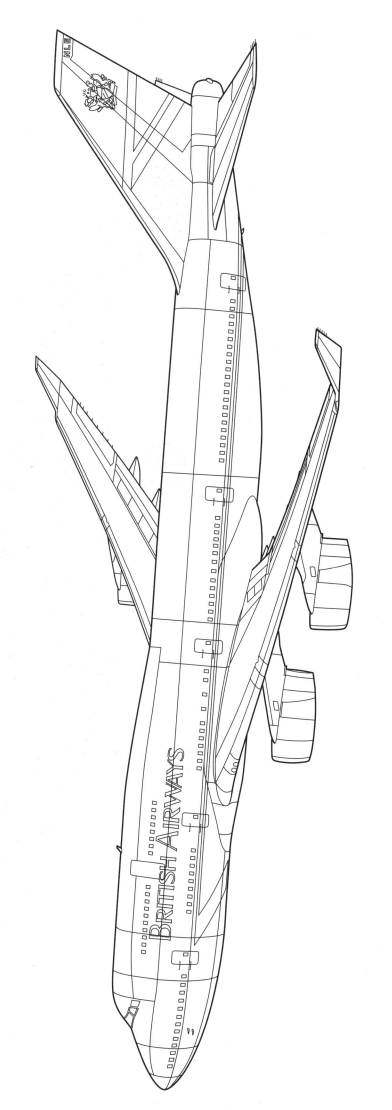

British Aerospace Sea Harrier

The Sea Harrier was a fighter that launched from aircraft carriers. Able to take off and land vertically (VTOL) as well as on short runways, it entered service with the Royal Navy in 1980 and served notably in the Falklands War (1982), as well as in both Gulf wars (1991, 2003) and in the Balkans Conflict (1992–2004).

Specifications

Maximum speed: 735 mph (1,183 km/h)
Range: 980 miles (1,480 km)
Crew: 1
Armament: Two 1.18 in (30 mm) cannon; up to 8,000 lb (3,628 kg) of ordnance, including bombs, rockets, air-to-surface and air-to-air missiles

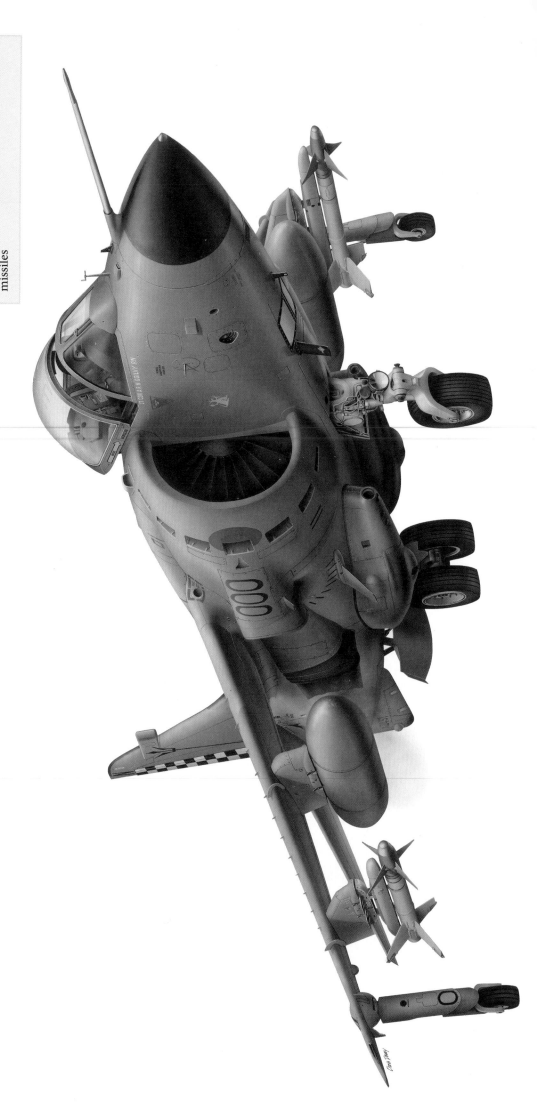

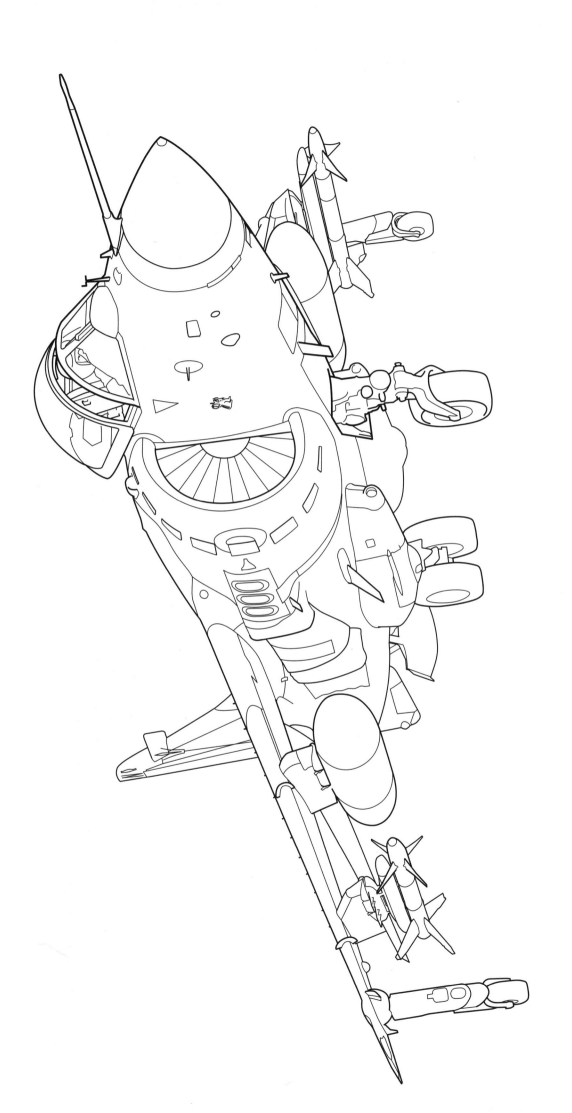

Lockheed F-117 Nighthawk

The F-117's main role is to attack high-value targets, such as command bunkers and air defense centers. Entering service with the United States Air Force in 1983, the F-117 "Stealth" was shaped to deflect radar signals and so enter enemy airspace undetected. With no radar of its own, it navigated by GPS. It was retired in 2008.

Specifications

Maximum speed: 700 mph (Mach 0.92)
Range: Classified
Crew: 1
Armament: Provision for 5,000 lb (2,268 kg) of stores in weapons bay, including air-to-surface laser-guided bombs and a B61 nuclear bomb

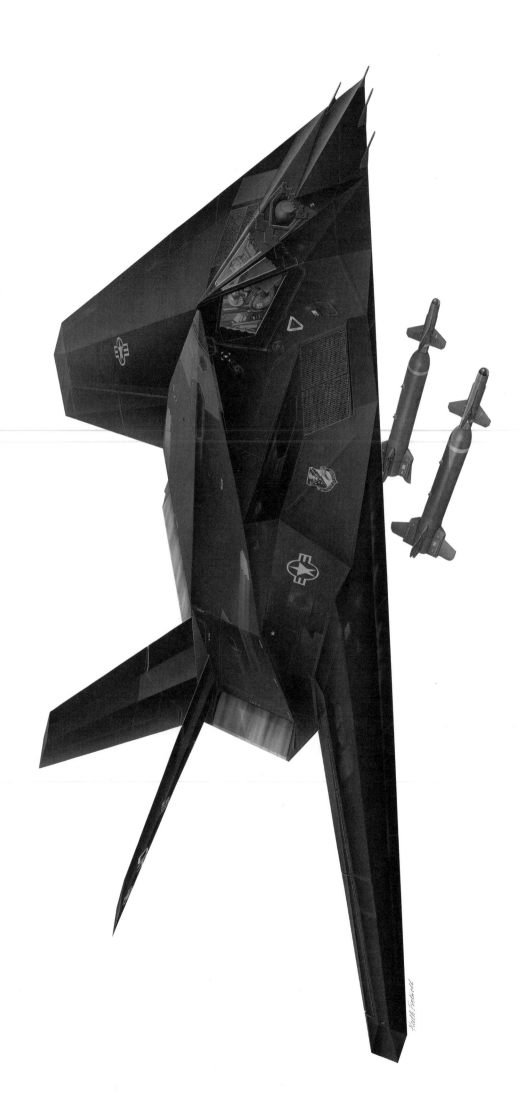

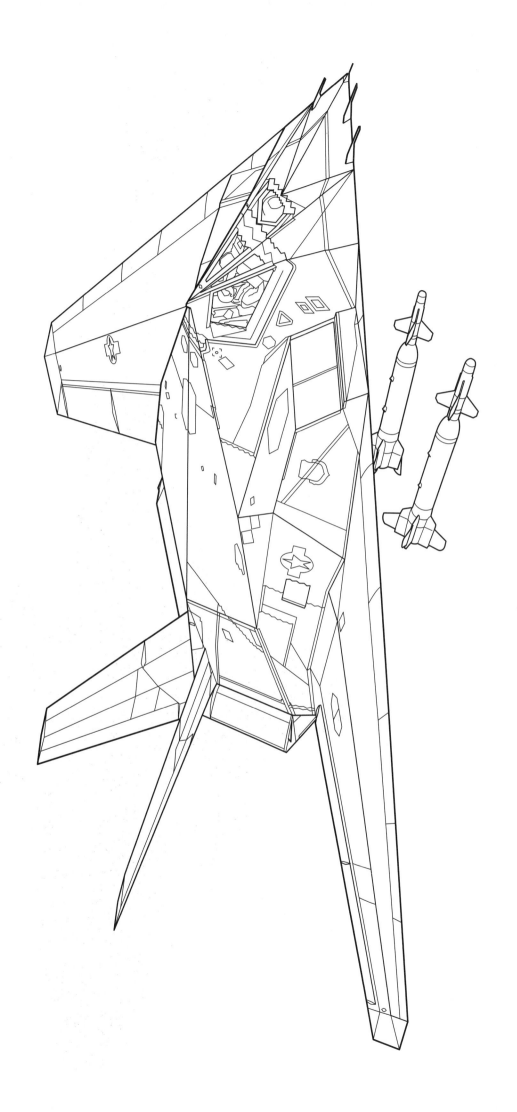

Boeing AH-64 Apache helicopter

Entering service with the US Army in 1986, the Apache flew the first missions in the 1991 Gulf War and served in Afghanistan. Models have also been exported to Israel, Egypt, Saudi Arabia, and Greece. Using a revolutionary helmet-mounted sighting system, the pilot or co-pilot can aim the cannon simply by looking at it.

Specifications

Maximum speed: 182 mph (293 km/h)
Range: 300 miles (428 km)
Crew: 2
Armament: One 1.18 in (30 mm) M230 chain gun; up to 6,263 lb (2,841 kg) of ordnance, including unguided rockets and missiles

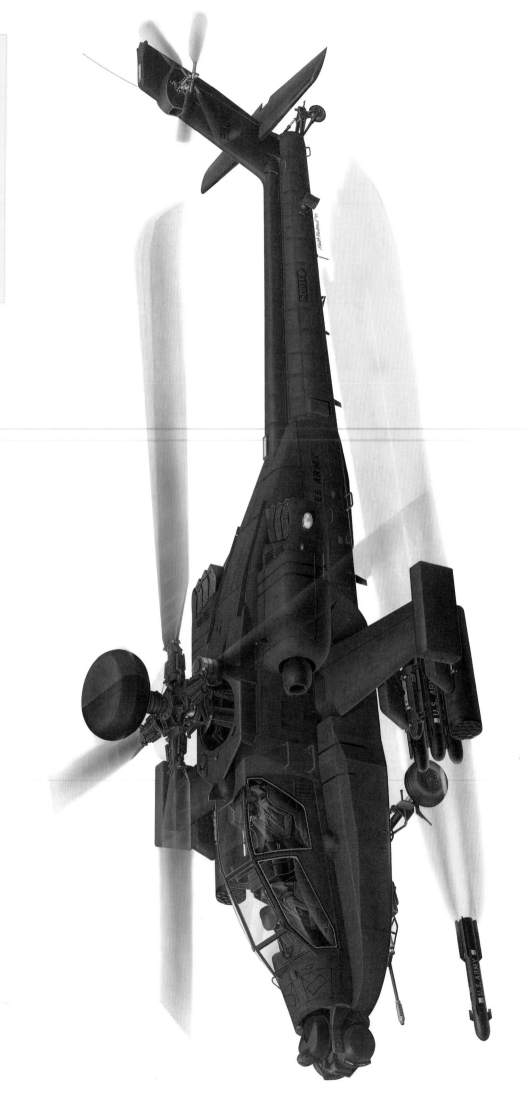

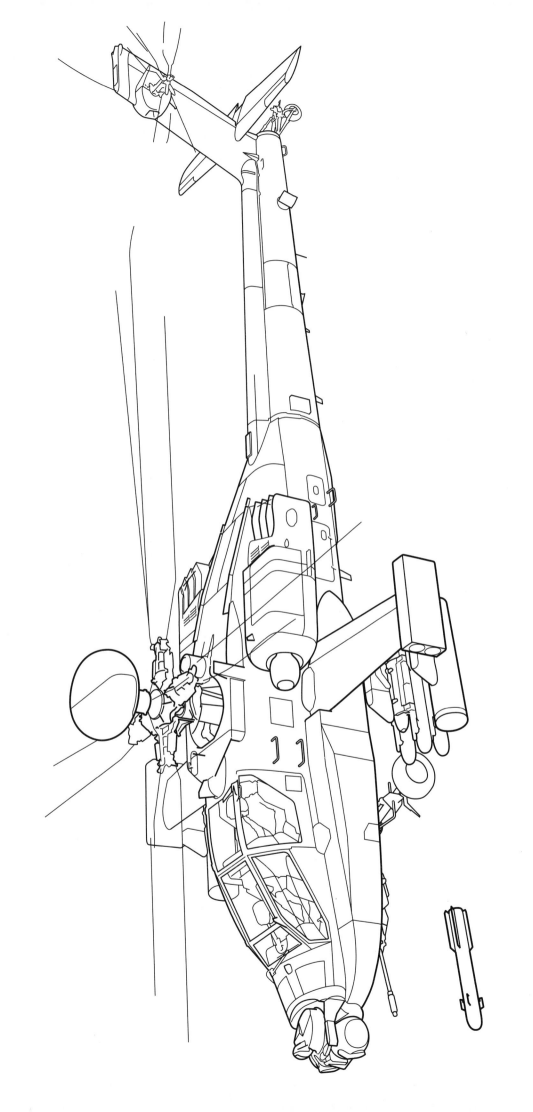

Northrop Grumman B-2 Spirit

Entering service in 1993, the B-2 Spirit is the world's most advanced strategic bomber. The aircraft's all-wing design makes it harder for radar to detect it. Acid is injected into its exhaust to hide the vapor trail. The exhausts themselves are set back from the edge of the aircraft to hide these heat sources from the ground.

Specifications

Maximum speed: 475 mph (764 km/h)
Range: 7,255 miles (11,675 km)
Crew: 4
Armament: Varied, included either 16 air-to-surface cruise missiles, or 16 free-fall nuclear bombs, or 80 500 lb (227 kg) bombs

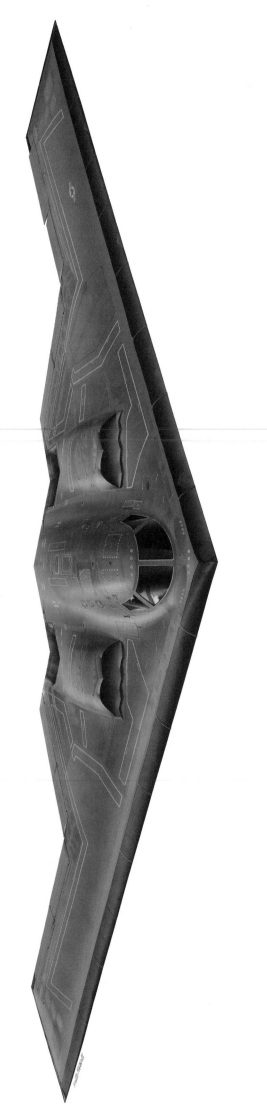

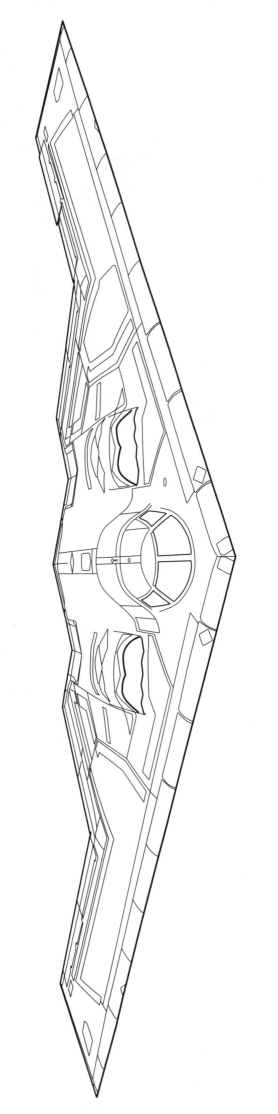

Lockheed Martin F-22 Raptor

The F-22 was designed to engage at long range with enemy aircraft in their own airspace using weapons when out of visual range. Its stealth qualities are achieved through a combination of factors, including its shape and radar absorbent materials. Unveiled in 1997, it was produced until 2011. By American law it cannot be exported.

Specifications

Maximum speed: 1,450 mph (2,335 km/h)
Range: 800 miles (1,285 km)
Crew: 1
Armament: One 0.78 in (20 mm) M61A2 Vulcan six-barreled Gatling cannon; eight air-to-air and four air-to-surface missiles; weapons bay capacity of 1,000 lb (454 kg)

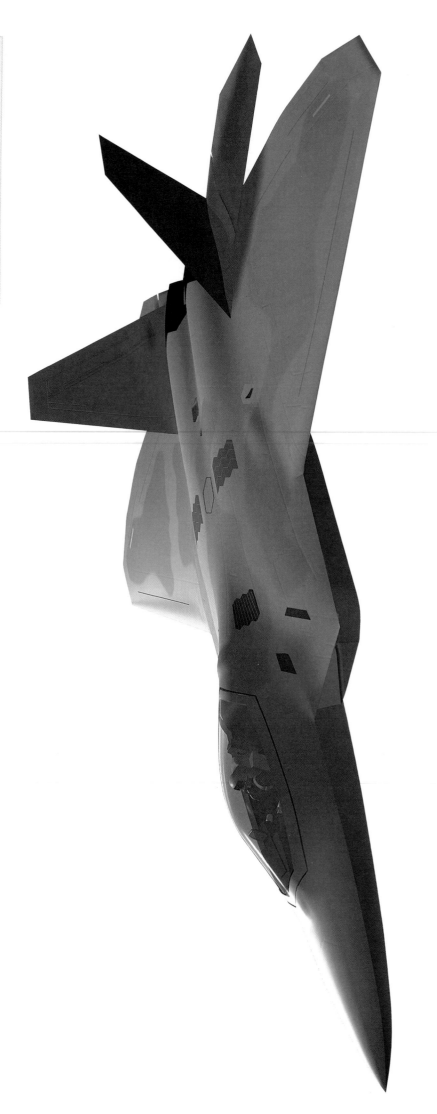

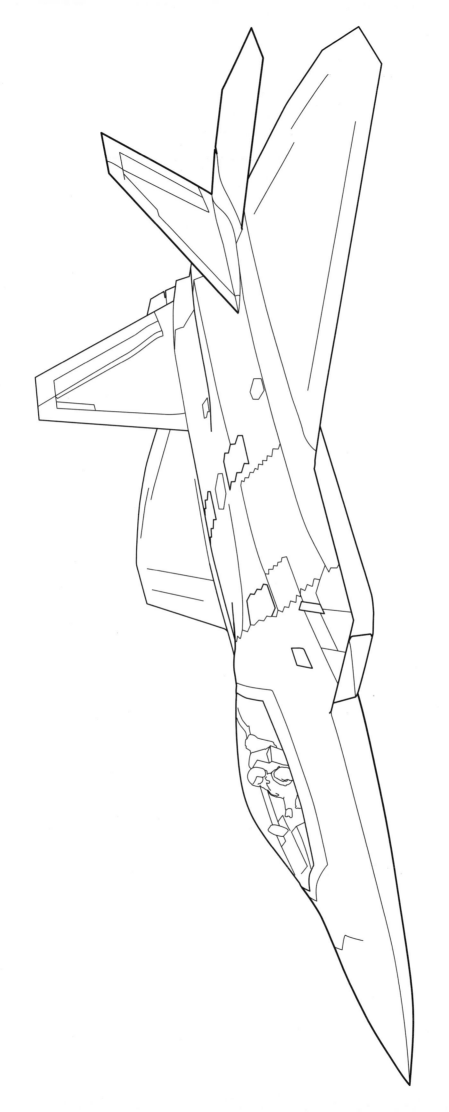

Airbus A380

Launched in 2005 as a rival to Boeing's 747-400 for high capacity, long-range routes, the A380 is now the world's largest airliner. A double-decker, it can carry 250 more passengers than the 747. Before being finally assembled in Toulouse, France, parts of the aircraft are constructed in Britain, Germany, and Spain.

Specifications

Maximum speed: 587 mph (945 km/h)
Range: 9,500 miles (15,400 km)
Crew: 2
Passengers: 644 (two-class configuration); 853 (maximum capacity)

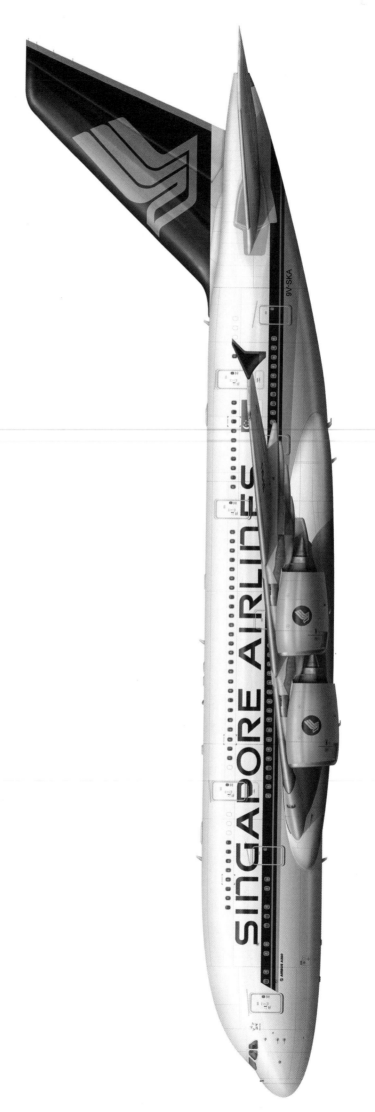

Glossary

Air-to-air missile
A rocket fired from one aircraft to attack another aircraft.

Air-to-air surface missile
A rocket fired from an aircraft against a ground target.

Chin turret
The bomber or navigator's position right at the front of an aircraft.

Dorsal turret
The gun position halfway back on the upper side of the aircraft.

Fuselage
The main body of an aircraft that holds the crew, passengers, and cargo.

GPS
Global Positioning System. It uses information from satellites to navigate.

Inflight refuelling
Where an aircraft can link up in the air with a supporting aircraft to receive a fuel top-up.

Litter patient
The number of medical patients on stretchers that an aircraft can carry.

Mach
Mach 1 is the speed of sound, which is approximately 768 mph (1,235 km/h).

Nose cheeks
Positions just to the side of the nose of an aircraft where guns can be placed.

Ordnance
Weapons and bombs carried by an aircraft.

Radar
A system that uses radio waves to calculate the range, altitude, direction, or speed of objects.

Retractable undercarriage
Wheels that are drawn up into the fuselage of an aircraft during flight.

Reconnaissance
Exploring enemy or unknown territory to obtain information.

Sextant
An instrument used to measure the angle between any two visible objects, usually something in the sky, such as a star or the moon, and the horizon. You can establish your own position by calculating this angle.

Stealth
Aircraft whose design allows them to fly without detection from radar.

Surface-to-air missiles
Missiles that are launched from the ground to attack aircraft.

Supersonic
Faster than the speed of sound (Mach 1).

Tailslide
An aerobatic maneuver where after a steep climb an aircraft can fall back tail first before entering a nose dive.

Underwing pylons
Points under the wings from which weapons can be launched.

Waist blisters
Points on the aircraft's fuselage in which guns can be mounted.